Color

Color is the essence of painting. The colors you choose will affect the viewers' perceptions and ultimately determine whether a painting evokes feelings of warmth and happiness, calm and intimacy, or drama and chaos. Understanding the basics of color and how colors relate to and interact with one another will help you create specific moods—as well as interest and unity—in your paintings. This book introduces all the basics, including everything you need to know to begin using color effectively in any medium, so you can start exploring the exciting world of color right away! —*William F. Powell*

CONTENTS

Focusing on Color Theory

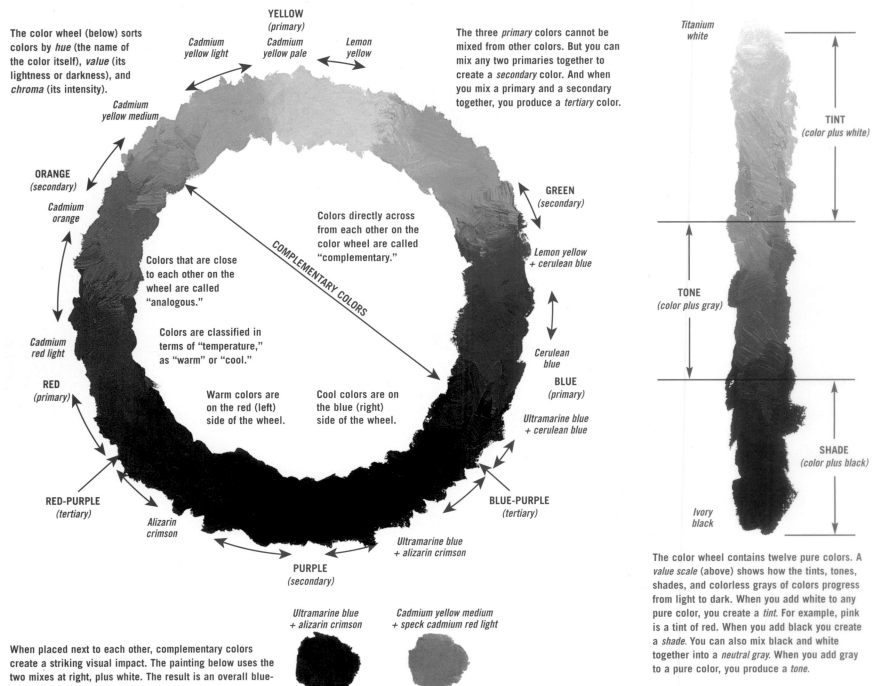

The color wheel (below) sorts colors by *hue* (the name of the color itself), *value* (its lightness or darkness), and *chroma* (its intensity).

YELLOW *(primary)*
Cadmium yellow light *Cadmium yellow pale* *Lemon yellow*

Cadmium yellow medium

ORANGE *(secondary)*

Cadmium orange

Colors that are close to each other on the wheel are called "analogous."

Colors are classified in terms of "temperature," as "warm" or "cool."

Cadmium red light

RED *(primary)*

Warm colors are on the red (left) side of the wheel.

RED-PURPLE *(tertiary)*

Alizarin crimson

PURPLE *(secondary)*

Colors directly across from each other on the color wheel are called "complementary."

COMPLEMENTARY COLORS

Cool colors are on the blue (right) side of the wheel.

GREEN *(secondary)*

Lemon yellow + cerulean blue

Cerulean blue

BLUE *(primary)*

Ultramarine blue + cerulean blue

BLUE-PURPLE *(tertiary)*

Ultramarine blue + alizarin crimson

The three *primary* colors cannot be mixed from other colors. But you can mix any two primaries together to create a *secondary* color. And when you mix a primary and a secondary together, you produce a *tertiary* color.

Titanium white

TINT *(color plus white)*

TONE *(color plus gray)*

SHADE *(color plus black)*

Ivory black

The color wheel contains twelve pure colors. A *value scale* (above) shows how the tints, tones, shades, and colorless grays of colors progress from light to dark. When you add white to any pure color, you create a *tint*. For example, pink is a tint of red. When you add black you create a *shade*. You can also mix black and white together into a *neutral gray*. When you add gray to a pure color, you produce a *tone*.

Ultramarine blue + alizarin crimson *Cadmium yellow medium + speck cadmium red light*

When placed next to each other, complementary colors create a striking visual impact. The painting below uses the two mixes at right, plus white. The result is an overall blue-purple tone with complements of orange-yellow.

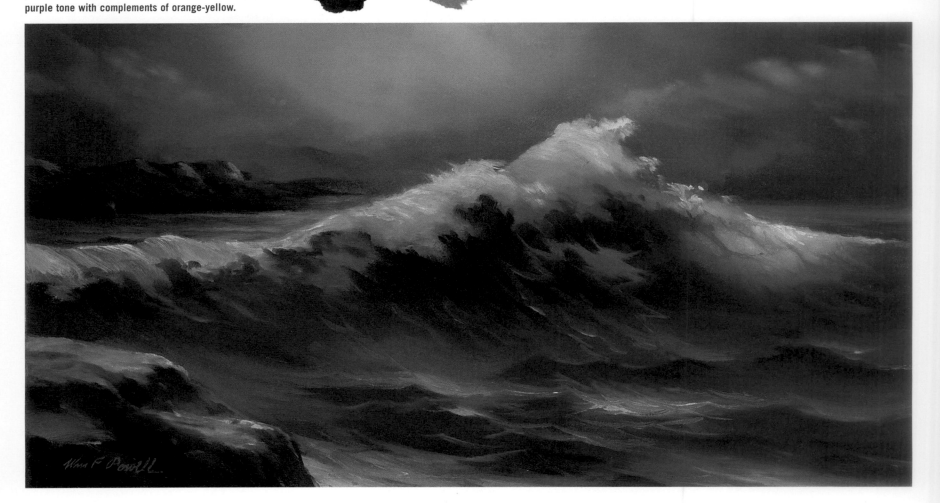

EXPLORING COLOR RELATIONSHIPS

The color wheel arranges colors into harmonious groups. It is useful for selecting colors for a palette and selecting the proper colors to use to gray other colors. You cannot gray colors by adding either black or a colorless gray; use another color instead. Direct complements gray each other better than any other colors on the wheel (this is called "natural graying"). Graying a pure color makes it more harmonious for use with other colors. A few direct complements and the neutrals that are created by mixing them are shown below.

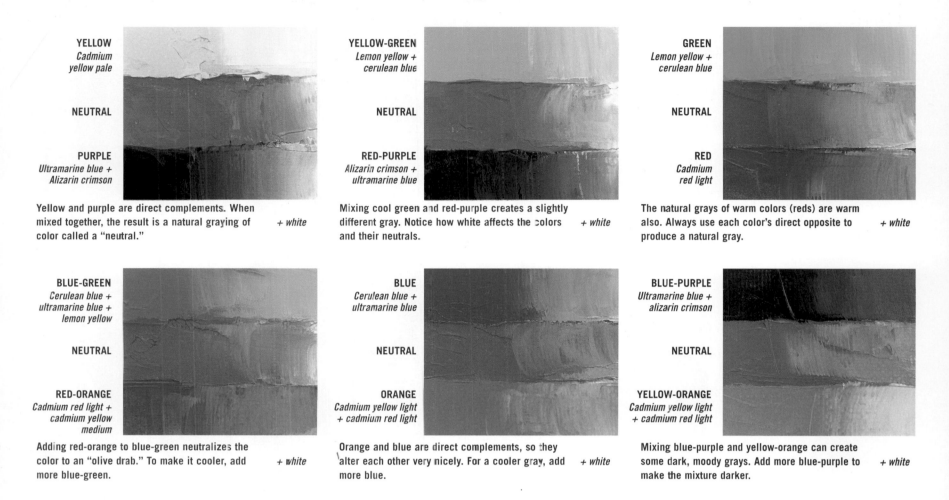

YELLOW
Cadmium yellow pale

NEUTRAL

PURPLE
Ultramarine blue + Alizarin crimson

Yellow and purple are direct complements. When mixed together, the result is a natural graying of color called a "neutral." + white

YELLOW-GREEN
Lemon yellow + cerulean blue

NEUTRAL

RED-PURPLE
Alizarin crimson + ultramarine blue

Mixing cool green and red-purple creates a slightly different gray. Notice how white affects the colors and their neutrals. + white

GREEN
Lemon yellow + cerulean blue

NEUTRAL

RED
Cadmium red light

The natural grays of warm colors (reds) are warm also. Always use each color's direct opposite to produce a natural gray. + white

BLUE-GREEN
Cerulean blue + ultramarine blue + lemon yellow

NEUTRAL

RED-ORANGE
Cadmium red light + cadmium yellow medium

Adding red-orange to blue-green neutralizes the color to an "olive drab." To make it cooler, add more blue-green. + white

BLUE
Cerulean blue + ultramarine blue

NEUTRAL

ORANGE
Cadmium yellow light + cadmium red light

Orange and blue are direct complements, so they alter each other very nicely. For a cooler gray, add more blue. + white

BLUE-PURPLE
Ultramarine blue + alizarin crimson

NEUTRAL

YELLOW-ORANGE
Cadmium yellow light + cadmium red light

Mixing blue-purple and yellow-orange can create some dark, moody grays. Add more blue-purple to make the mixture darker. + white

GRAYING WITH SPLIT COMPLEMENTS

Yellow-green

Green

Neutral

Red

Blue-green

Select a color and find its direct complement. Then look at the next lighter color and next darker color of the direct complement; these two colors are the first color's *split complements*. Split complements allow for a much broader palette of colors; they also create a larger spectrum for graying colors naturally. Notice that red can be grayed with either yellow-green or blue-green; each would produce a different gray, providing many more colors to work with. Apply this diagram clockwise around the color wheel to see the tremendous variety of mixtures possible.

CREATING HARMONY WITH ANALOGOUS COLORS

Colors that have a close association with each other in hue, value, or tone are considered harmonious, and this harmony is pleasing to the eye. *Analogous colors*—or colors that are close to one another on the color wheel, such as yellow-orange, orange, and red-orange—are harmonious because they are so similar to each other. Look at these three colors on the wheel. The color in the middle (orange) is the "ruling" color. This means that the other two colors contain orange, and orange can most easily alter them. Move around the wheel and select any three colors in a row. The color in the center of the three is always the ruling color. Study the different families of color on the wheel and try to decide which colors are analogous and which are not. (For example, some yellows are very similar, yet others are very different.)

Yellow-orange

Orange

Red-orange

Using Cool Palettes

The palette for this painting is basically cool (see the color wheel on page 2), but it does contain some warm colors. Cool colors tend to be associated with morning, evening, or winter—all quiet times. But "temperature" can vary even within a hue. For example, permanent blue is a warm blue whereas cerulean blue is cooler. Use the color swatches below as a guide to duplicating this painting.

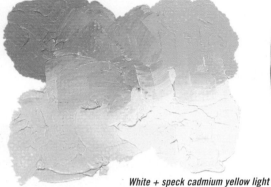

White + permanent blue *White + cerulean blue*

White + speck cadmium orange *White + speck permanent blue* *White + speck cadmium yellow light* *Viridian*

Burnt umber + alizarin crimson *White + cadmium orange* *White + permanent blue* *White*

Little Blue Christmas Tree

This moonlight scene has an extremely simple palette. As you can see, only three colors and white are used. The warmth of the "pathway of light" in the snow is created by the play of warm blue (permanent blue) and cool blue (cerulean blue) against the warm glow of titanium white. The background colors were applied very thinly and blended with a soft sable brush. The light colors were applied thickly and allowed to appear dense against the soft, delicate background.

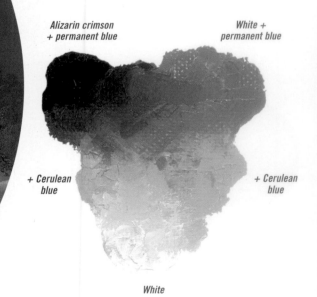

Alizarin crimson + permanent blue *White + permanent blue*

+ Cerulean blue *+ Cerulean blue*

White

Silent Night

Using Warm Palettes

This painting is very warm in overall tone. Warm colors are associated with energy and excitement, summer, and afternoon or sunsets. The blue and white snow appears iridescent against the warmth of the orange and yellow mixes. Note that cool colors tend to recede, whereas warm colors appear to come forward.

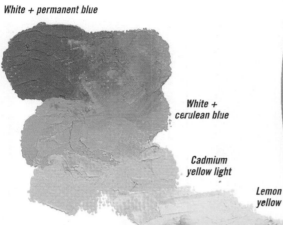

White + permanent blue

White + cerulean blue

Cadmium yellow light

Lemon yellow

Burnt umber + phthalo red rose

+ phthalo red rose

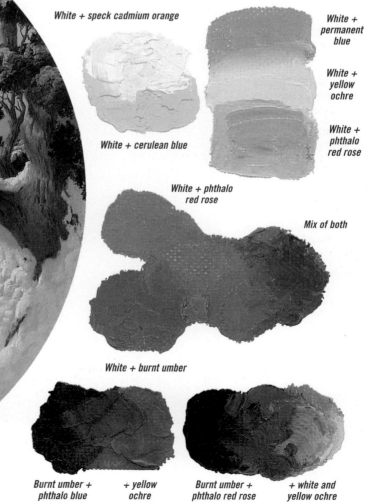

Winter's Sun

Use the mixes below to create this delightful scene. Paint the background thinly, and then paint the blue undercolors of the snow. Create highlights by painting thicker light colors over the blue areas.

White + speck cadmium orange

White + permanent blue

White + cerulean blue

White + yellow ochre

White + phthalo red rose

White + phthalo red rose

Mix of both

White + burnt umber

Snug and Warm

Burnt umber + phthalo blue

+ yellow ochre

Burnt umber + phthalo red rose

+ white and yellow ochre

5

Building Color Harmony with Cool Tones

LEFT SKY
White + ultramarine blue + cadmium red light

CLOUDS
White + cadmium orange

MOUNTAIN SNOW
White + cadmium orange

BACK MOUNTAINS
White + ultramarine blue + cadmium red light

MAIN MOUNTAIN
Same as above but with more ultramarine blue

HAZE
White + cerulean blue

TREES
Ultramarine blue + burnt umber + yellow ochre

TRUNKS
Yellow ochre + cadmium orange

SHADOW SNOW
White + ultramarine blue

SUNLIT SNOW
White + cadmium yellow light + cadmium orange

ROCKS AND LAND
*Paint burnt umber + alizarin crimson base
Draw ultramarine blue + yellow ochre into base*

ROCK HIGHLIGHTS
white + cadmium orange and yellow ochre

RIGHT SKY
White + cerulean blue

MOUNTAIN SUNLIT SNOW
White + cadmium orange

SHADOW SNOW
White + ultramarine blue

Add a little more cadmium red light to the right side of the mountain

DARK TREE FOLIAGE
Ultramarine blue + burnt umber and yellow ochre

MIDDLE GREENS FOR TREES AND GRASS
2 parts yellow ochre + 1 part ultramarine blue

FOLIAGE, GRASS HIGHLIGHTS
Cadmium yellow light + ultramarine blue and cerulean blue

Paint lighter leaf and grass forms over dark underbase.

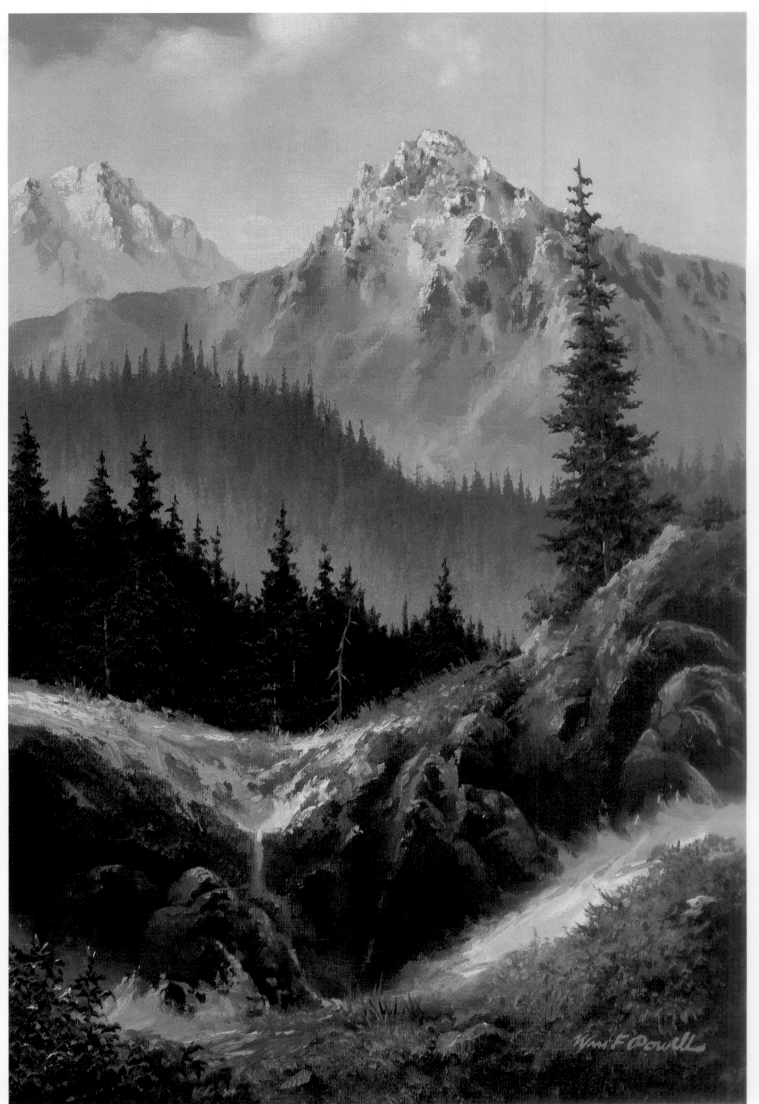

MOUNTAIN MAGIC This example illustrates a harmonious combination of cool tones. Before you begin painting, first mix the colors to ensure their harmony, and then paint from dark to light. To create fresh, crisp highlights, let some of the colors dry before painting the lights over them. Scrub in rough color all over the canvas so you do not misinterpret how the color should be mixed by seeing it against the white of a blank canvas (it is better to view color against color). Develop the scene by first applying the darks and then painting the lighter colors over them to create form and depth.

Building Color Harmony with Warm Tones

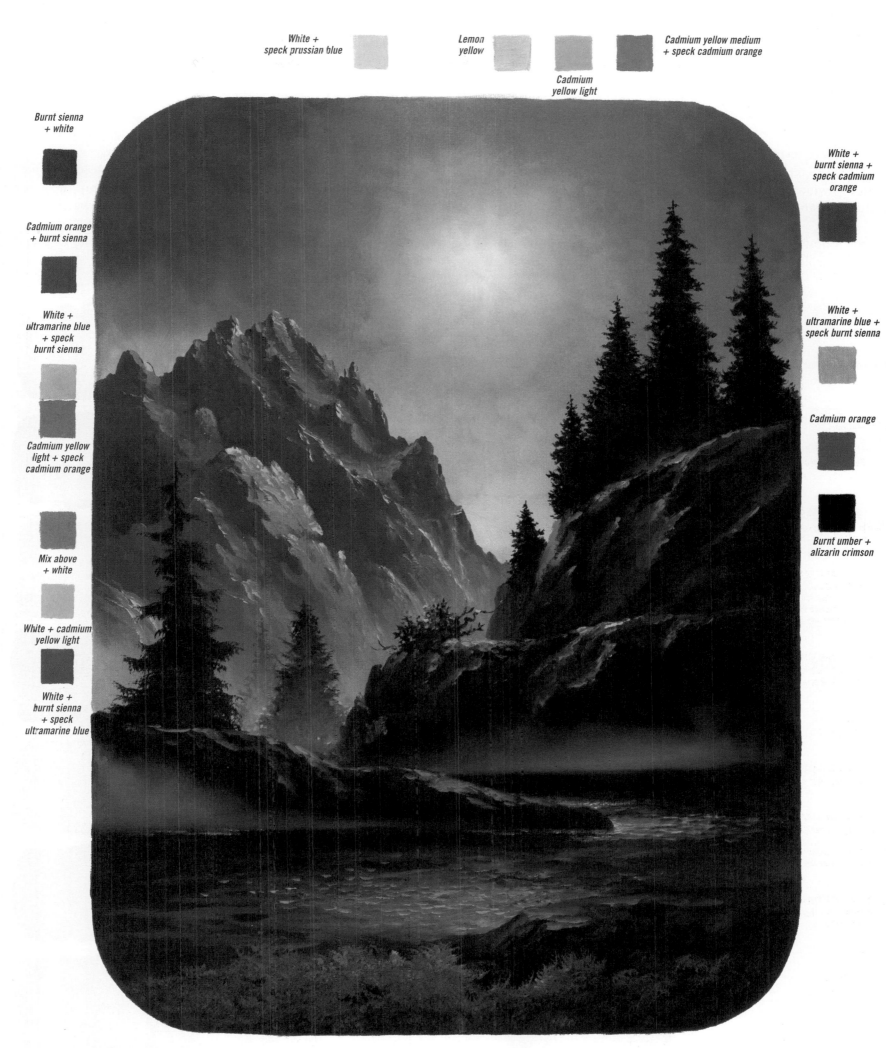

Burnt sienna + white

Cadmium orange + burnt sienna

White + ultramarine blue + speck burnt sienna

Cadmium yellow light + speck cadmium orange

Mix above + white

White + cadmium yellow light

White + burnt sienna + speck ultramarine blue

White + speck prussian blue

Lemon yellow

Cadmium yellow light

Cadmium yellow medium + speck cadmium orange

White + burnt sienna + speck cadmium orange

White + ultramarine blue + speck burnt sienna

Cadmium orange

Burnt umber + alizarin crimson

GOLDEN SUNSET Warm colors are used to establish the harmony in this painting, though a slight touch of cool (white with a speck of Prussian blue) in the center distance provides contrast and balance. There is a generous amount of yellow used in this painting; always be careful when using yellow, as it can become very garish if not treated delicately. Avoid using it in a raw state anywhere other than in the glow area in the sky. And make the glow appear brilliant; all the colors around it should be toned back with a darker value (see page 14) within the same family of color or grayed with a complement—for example, orange is deepened by adding burnt sienna or burnt umber and grayed by adding blue.

7

Mixing Color

The information you've already learned about color—including primary colors, complementary and analogous colors; warm and cool variations; and tints, shades, and tones—will provide you with a never-ending array of color-mixing possibilities. Experiment with color mixes to help you develop your own palettes for painting compositions.

Following are several pages of color mixtures to get you started. The large O's represent mixes with more white, and the small o's mean less white. One dot indicates there's very little of the color, two dots means the mix uses more, and so on.

Use the following charts as a guide to mixing the various reds, yellows, purples, blues, and greens as indicated. Then, when you

feel comfortable with these exercises, create a chart of your own color combinations. Remember: As you mix, take notes on the amounts you use and make swatches of the final colors. These records will become a handy reference, and they'll serve you all of your painting life.

As you paint, have fun—and watch the color excitement grow!

Note: When painting with watercolors, add water instead of white paint. Adding water thins the color, allowing the white of the paper to show through and creating a tint of the color. Some watercolorists use Chinese white (or gouache) to accent the lightness of the color, but this opaque paint destroys the true transparency of the watercolor.

REDS

FLESH TINT	O White / •• Vermilion / • Cadmium red / • Burnt sienna
FLESH SHADOWS	O White / • Viridian green / • Raw umber / •• Vermilion
FLESH HIGHLIGHTS	O White / • Cadmium yellow medium / •• Burnt sienna
LIP AND CHEEK COLORS	O White / •• Cadmium red light / • Vermilion
LIP AND CHEEK TINTS	O White / • Cadmium red light / • Vermilion
PUPILS, DARK EDGE OF IRIS, NOSTRIL OPENINGS	•••• Raw umber / ••• Ultramarine blue / •••• Black (if you want it darker)
RED FLOWERS	O White / •• Cadmium red light / •• Vermilion
LIGHT RED FLOWER VARIETY	O White / • Cadmium red light / •• Vermilion / • Cadmium yellow medium

COMPLEMENT SHADOWS	•• Raw sienna / • Phthalo green / •• (or viridian green)
BURNT ORANGE VARIATIONS	• Cadmium yellow medium / • Vermilion / • Raw umber
CHAMPAGNE	O White / ••• Cadmium yellow medium / •• Vermilion
GOLDEN BROWN	• Vermilion / ••• Cadmium yellow medium / •• Raw umber
PINK	O White / • Vermilion / • Magenta or rose madder
RICH CARDINAL RED	•• Vermilion / • Rose madder
CERISE PINK (SLIGHTLY PURPLE-RED)	o White / • Rose madder / •• Vermilion
CRIMSON	• Vermilion / •• Rose madder

Color	Recipe	Swatch
GERANIUM	O White • Vermilion •• Rose madder	
HENNA (SLIGHTLY REDDISH BROWN)	•• Vermilion •• Cadmium yellow medium •• Raw umber • (or Indian red)	
MAHOGANY	•• Vermilion ••• Raw umber • Rose madder ••• Black	
MAROON	••• Vermilion ••• Rose madder •• Black	
MULBERRY	••• Rose madder •• Ultramarine blue	
OLD ROSE	O White •• Rose madder	
PIMENTO	O White •• Cadmium yellow medium ••• Vermilion	
PEACH	O White ••• Cadmium yellow medium •• Vermilion	
PRIMROSE (WARM REDDISH ORANGE)	O White ••• Cadmium yellow medium ••• Vermilion	
RED GRAPES	••• Cobalt blue •• Cadmium red medium	
SHADOWS OF GRAPES	••• Rose madder ••• Cobalt blue • Burnt sienna	

YELLOWS

Color	Recipe	Swatch
BARN YELLOW	•• Rose madder • Indian red •• Cadmium yellow medium	
YELLOW FLOWERS	O White ••• Cadmium yellow light	
SHADOWS	O White ••• Cadmium yellow light •• Burnt sienna	
COOL SHADOWS	O White ••• Cadmium yellow light •• Burnt sienna • Phthalo green	
DARK YELLOW FLOWERS	o White ••• Cadmium yellow dark • Vermilion	
BEACH TAN	O White •• Cadmium yellow medium • Vermilion •• Raw umber	
BEIGE	O White •• Cadmium yellow medium •• Vermilion	
RICH CANARY YELLOW	•••• Cadmium yellow deep (Add white to lighten)	
CREAM	O White • Cadmium yellow medium • Vermilion	
FAWN	O White •• Cadmium yellow medium •• Vermilion • Raw umber	
IVORY	O White •• Cadmium yellow medium • Vermilion • Raw umber	

		
LEMON	*0 White* •• *Cadmium yellow light* • *Prussian blue*	
GOLD	*0 White* •• *Cadmium yellow medium* •• *Vermilion* •• *Raw umber* *Use white and cadmium yellow for highlights.*	
GOLDEN YELLOW	*0 White* •• *Cadmium yellow light* • *Vermilion*	
TANGERINE	*0 White* •• *Vermilion* •• *Cadmium yellow light*	
TERRA COTTA	*0 White* •• *Cadmium yellow medium* •• *Vermilion* • *Raw umber*	

PURPLES

		
PURPLE, GRAPE, AND PLUMS	••• *Cobalt blue* •• *Cadmium red medium*	
SHADOWS	•• *Rose madder* ••• *Cobalt blue*	
LIGHT PLUM	*0 White* • *Cobalt blue*	
PURPLES	*o White* ••• *Rose madder* ••• *Ultramarine blue* *(For a variety of purples, use cobalt blue, phthalo blue, plus other blues)*	
REDDISH FUCHSIA	*0 White* ••• *Rose madder* •• *Ultramarine blue*	
INDIGO	*0 White* ••• *Ultramarine blue* •• *Black*	

		
LAVENDER	*0 White* •• *Ultramarine blue* •• *Rose madder*	
LILAC	*0 White* ••• *Ultramarine blue* •• *Rose madder*	
DEEP PURPLE	••• *Rose madder* •••• *Ultramarine blue*	
ORCHID	*0 White* •• *Rose madder* • *Ultramarine blue*	
PANSY	*o White* •• *Rose madder* ••• *Ultramarine blue*	

BLUES

		
FRUITS (PLUMS, GRAPES)	*o White* •••• *Cobalt blue*	
PLUM AND GRAPE SHADOWS	••• *Cobalt blue* ••• *Ultramarine blue*	
REFLECTED LIGHT FOR PLUMS, GRAPES, EGGPLANT, ETC.	••• *Ultramarine blue* •• *Cadmium red or rose madder*	
PLUM AND GRAPE HIGHLIGHTS	*0 White* •• *Rose madder* • *Cerulean blue*	
ALICE BLUE	*o White* •• *Ultramarine blue*	
SKY BLUE LIGHT	*0 White* •• *Prussian blue*	

SKY BLUE DEEP	0 White	
	••• Prussian blue	

NAVY	•• Black	
	•• Prussian blue	
	•• Ultramarine blue	

BABY BLUE	0 White	
	•• Prussian blue	

SOFT GRAY	0 White	
	•• Black	
	• Rose madder	

TURQUOISE	o White	
	••• Prussian blue	
	• Cadmium yellow medium	

LIGHT WISTERIA BLUE	0 White	
	•• Rose madder	
	• Ultramarine blue	

BLUE-VIOLET	o White	
	•• Rose madder	
	•••• Ultramarine blue	

The two main types of shadows are self shadows and cast shadows. In blue-violet, a deeper, shaded purple creates a lively shadow.

GREENS

In most landscapes, the greens are dominant, so you add elements using other colors for variety. Think about balancing the different colors in your composition. Here are a few greens to think about and mix.

APPLE GREEN LIGHT	o White	
	•• Prussian blue	
	•• Cadmium yellow light	

APPLE GREEN DARK	0 White	
	•• Cadmium yellow medium	
	•• Prussian blue	

MEDIUM GREEN	0 White	
	••• Cadmium yellow medium	
	• Prussian blue	
	• Raw umber	

DARK YELLOW GREEN	•• Cadmium yellow medium	
	•••• Prussian blue	

JADE	o White	
	•• Cadmium yellow medium	
	••• Prussian blue	

DEEP GREEN	o White	
	•• Cadmium yellow medium	
	•• Prussian blue	

NILE GREEN	0 White	
	••• Prussian blue	
	•• Cadmium yellow medium	

OLIVE GREEN	••• Prussian blue	
	•• Cadmium yellow medium	
	•• Raw umber	

OLIVE DRAB	••• Cadmium yellow medium	
	•• Raw umber	
	• Black	

PEA GREEN	0 White	
	•• Prussian blue	
	•• Cadmium yellow medium	

SEA GREEN	••• Prussian blue	
	•• Cadmium yellow light	

BEVERLY'S GREEN	•••• Manganese blue	
	•• Lemon yellow	
	• White	

Color mixing can be endless. Simply by changing the slightest degree of any of these mixtures, you will end up with another chart with just as many (or more) colors. Don't be afraid to try new mixtures. Invent some colors of your own. Add to each of these color groupings—you will be amazed at the beautiful results!

Make notes and keep track of everything you do so you will be able to duplicate a color or alter it if needed in the future. Remember: Don't think that you have to memorize all the color formulas and their names. That is too much for anyone. Just keep a general idea of the colors and what they do to one another, and mixing will become second nature to you.

Note: Since paint colors vary from manufacturer to manufacturer, you might notice a difference between some of your mixtures and these samples. (Colors also may vary slightly when printed.) When you use these samples as general guides, though, you will soon be successfully mixing beautiful colors.

Glazing Transparent Colors

Once you've learned to mix opaque colors, the next step is to practice using colors in thin, transparent layers, called "glazing." Glazing works in the same way that looking through glasses with amber lenses makes everything appear more yellow. When you apply a transparent color over another color, the transparent color visually alters the first; the light rays mix, creating a visual color blend. Light rays penetrate the layers, strike the opaque surface of the paint (or, in an all-glaze painting, the canvas), and then reflect back to the eye in various visual color mixes. When used correctly, glazing can give great depth to a painting.

It's important to use extremely transparent media for this kind of painting (see page 13), and you must allow each layer to dry thoroughly before applying the next. In this example, the green water is painted with combinations of Indian yellow, phthalo blue, and burnt sienna, layered individually or blended (see page 13). For areas of bluer water, a stronger glaze of blue or several thin layers of blue are used (with Indian yellow added for green).

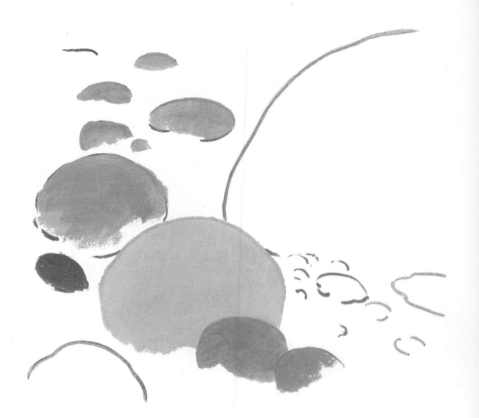

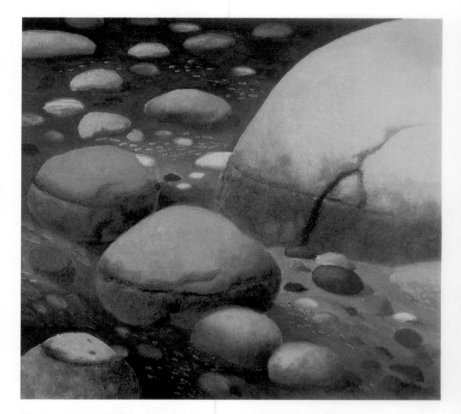

Glazes are usually applied in a slightly deeper value than needed and then softened back to the desired depth by wiping off paint with a soft brush, cloth, or finger. Both opaque and glaze techniques can be used in a painting, as shown here. This simple exercise shows how transparent glazing makes creating great detail possible.

GLAZING UNDERWATER ROCKS

Step 1: First establish the placement of the major rocks using white, raw umber, ultramarine blue, and yellow ochre.

Step 2: Use the same colors to paint the creek bottom. Wipe away some of the paint on the lighter rocks, letting the white base show through. Begin shading the rock forms, and then let them dry.

Step 3: Thin raw umber with a glaze medium and paint the rock textures and shadows. Use stronger, less-diluted glazes for dark areas and weaker, more watery glazes for lighter ones. Let the paint dry.

Step 4: Now paint the water, blending glazes or layers of Indian yellow, phthalo blue, and burnt sienna. After this dries, paint dappled light around and over the submerged rocks, using white, permanent blue, and the water mix. For water lines and sparkles, gently scrape away color, allowing the white underbase to show through.

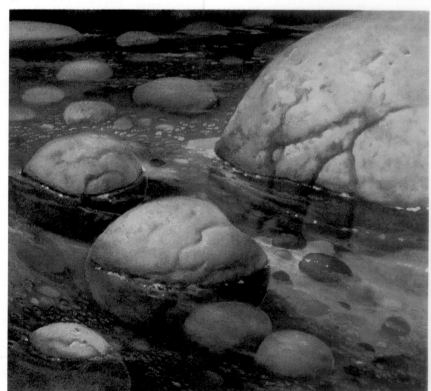

Comparing Glazes

This chart shows some of the colors you can achieve by glazing over dry color. (Each layer must be completely dry before being glazed.) Notice the delicate color changes that occur and the difference in the color over the white base and the color base. (Note: Some of these colors are not totally transparent; they show how a translucent mix can be thinned to a milky glaze—a form of "scumbling" color.)

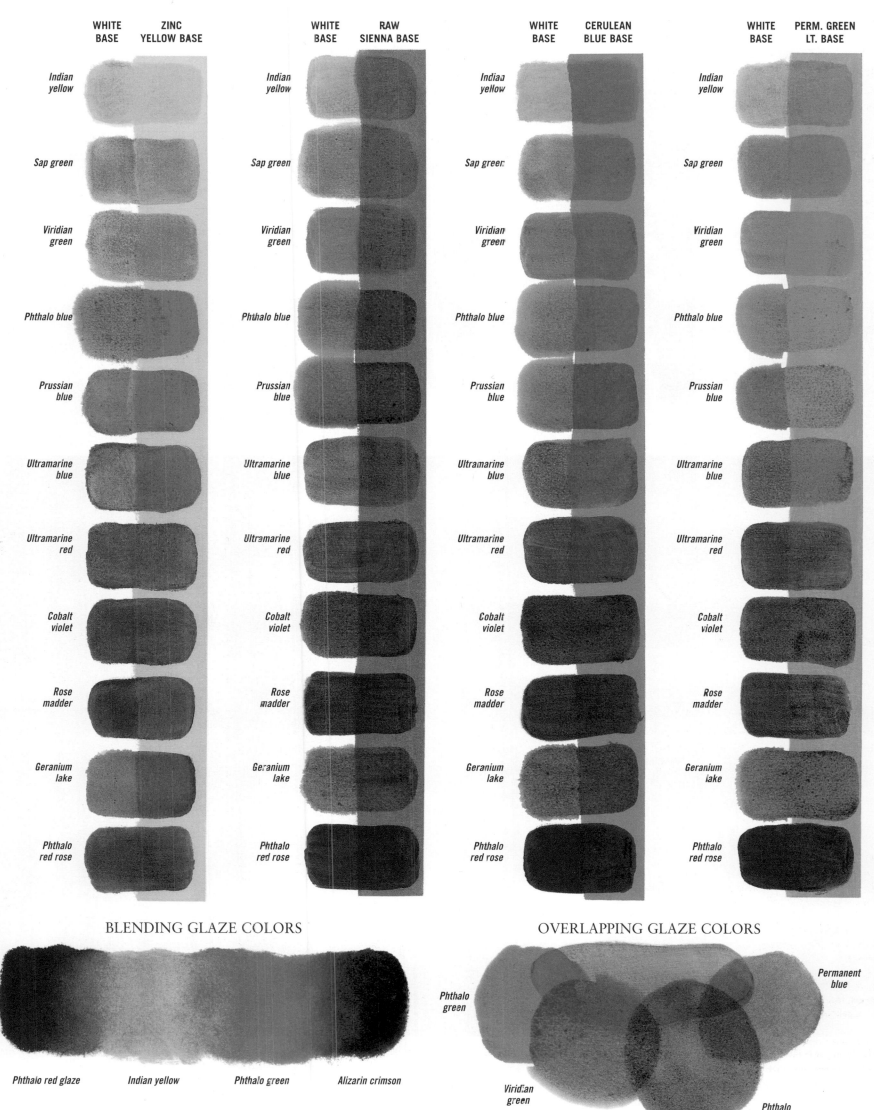

| WHITE BASE | ZINC YELLOW BASE | WHITE BASE | RAW SIENNA BASE | WHITE BASE | CERULEAN BLUE BASE | WHITE BASE | PERM. GREEN LT. BASE |

Indian yellow · Sap green · Viridian green · Phthalo blue · Prussian blue · Ultramarine blue · Ultramarine red · Cobalt violet · Rose madder · Geranium lake · Phthalo red rose

BLENDING GLAZE COLORS

Phthalo red glaze · Indian yellow · Phthalo green · Alizarin crimson

OVERLAPPING GLAZE COLORS

Phthalo green · Viridian green · Permanent blue · Phthalo red rose

13

Using Light and Dark Values

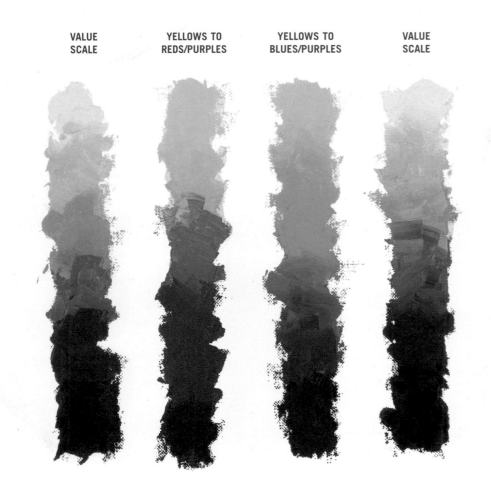

VALUE SCALE	YELLOWS TO REDS/PURPLES	YELLOWS TO BLUES/PURPLES	VALUE SCALE

Like the color wheel, the value scale has both light and dark colors. Yellow is the lightest on the color wheel, and white is the lightest on the value scale; purple is darkest on the wheel, and black is the darkest on the scale. It is the variations in value that create the sense of form and dimension in your paintings.

For a lighter value, add white to a color. But to keep colors fresh and clean when adding white, also add a speck of the color *above* it on the color wheel. For example, when adding white to cadmium red light, add just a speck of orange also. The same rule applies in reverse when adding black to a color to darken the value. Add a touch of the color *below* it on the color wheel for freshness.

The examples at left show the hues of the color wheel compared to the lights and darks of the value scale.

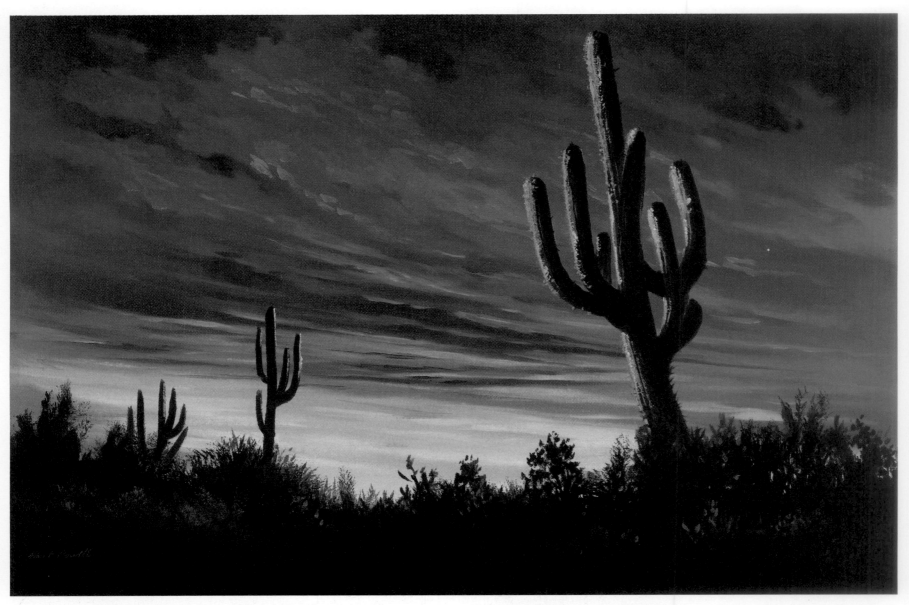

Because yellow is the lightest value on the color wheel and purple is the darkest, the combination of the two produces a strong and dramatic contrast. The light, lemon yellow values are set off by the darker purple ones, making the sky appear to glow. Try this exercise on your own, and don't be afraid to experiment with varied value mixes!

PREPARING TINTS AND SHADES

The colors on this page have either been lightened (tinted) with white or (shaded) with black. Other (mostly analogous) colors were also added to keep the mixes fresh, as suggested on page 14. Notice the first three mixtures: The mix of white and burnt umber is rather dull and lifeless, but it becomes livelier when other colors are added. Once you obtain a soft color, you can use it as a base for other mixes. The color mixtures directly below were made with titanium white. The second set (at the bottom) was mixed using ivory black.

White and burnt umber + alizarin crimson	
Above mix + Naples yellow + cadmium orange	
White and burnt umber + alizarin crimson + ultramarine blue	
Cadmium orange + white + cadmium yellow medium	
Cadmium yellow medium + white + cadmium orange	
Cadmium yellow light + white + Naples yellow	

Phthalo yellow-green + white + zinc yellow	
Permanent green light + white + phthalo yellow-green	
Viridian green + white + permanent green light	
Cerulean blue + white + viridian green	
Prussian blue + white + viridian green	
Ultramarine blue + white + phthalo blue	

Cadmium yellow medium + ivory black + cadmium orange	
Yellow ochre + ivory black + cadmium orange	
Cadmium orange + ivory black + cadmium red light	
Cadmium red light + ivory black + alizarin crimson	
Raw sienna + ivory black + burnt sienna	

White and viridian green + ivory black + cerulean blue	
Cerulean blue + ivory black + ultramarine blue	
Cerulean blue + ivory black + viridian green	
Permanent green light + ivory black + viridian green	
Phthalo yellow-green + ivory black + permanent green light	

Observing Colors in a Scene

For practice, try to mix these color swatches, and notice where they are located within the painting. Match the mixtures as closely as possible, but don't worry if your colors vary slightly; you can still create a beautiful mountain scene.

White + yellow ochre + speck ultramarine blue

White + speck cadmium red light

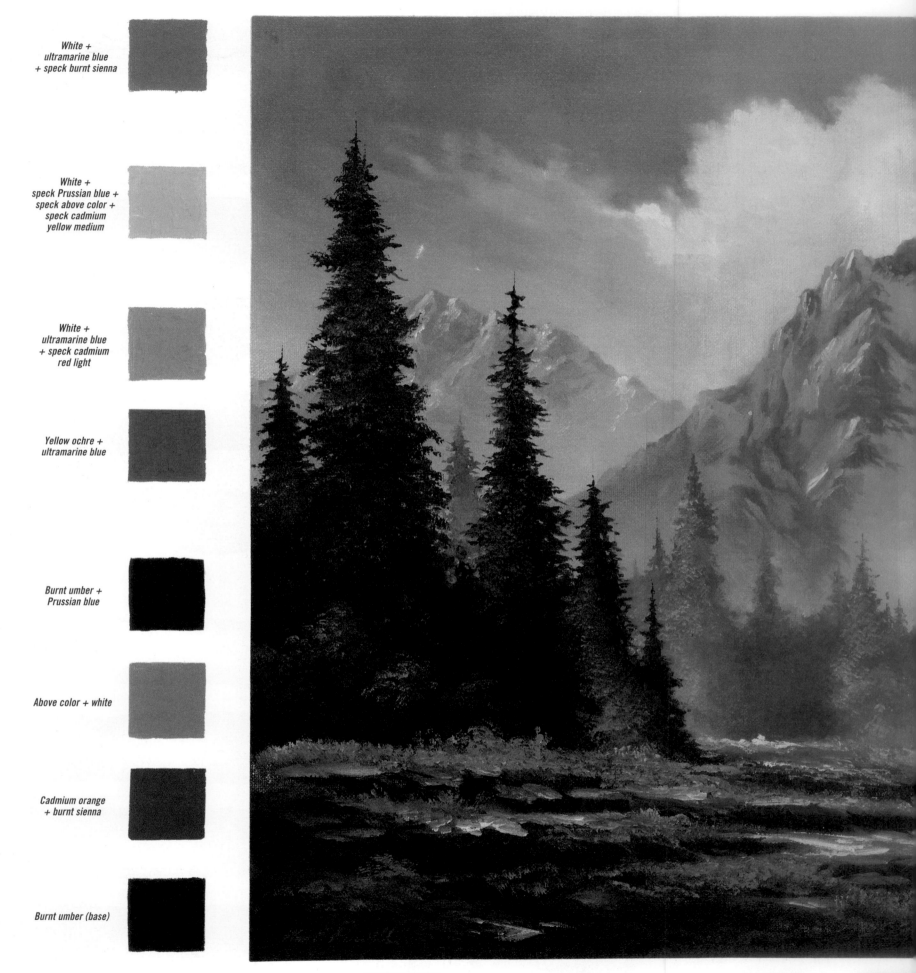

White + ultramarine blue + speck burnt sienna

White + speck Prussian blue + speck above color + speck cadmium yellow medium

White + ultramarine blue + speck cadmium red light

Yellow ochre + ultramarine blue

Burnt umber + Prussian blue

Above color + white

Cadmium orange + burnt sienna

Burnt umber (base)

Block in the darkest colors first, establishing the silhouetted masses of the objects in two dimensions—height and width. They appear flat at this stage. Then, when you add the lighter values and highlights, you create texture, depth, and form, giving the illusion of three dimensions.

White + yellow ochre

Lemon yellow + speck Prussian blue

Cadmium yellow light

Yellow ochre + sienna + sp ultramarine

16

White + ultramarine blue (shadow snow)

White + speck cadmium orange

White + ultramarine blue + yellow ochre + speck cadmium red light

White + Prussian blue

This scene is bathed in afternoon sunlight, so the mixtures are warmer than they would be in a morning scene. A misty haze between the mountains and trees is a great softening effect; adding white mixed with a little blue creates the illusion of aerial perspective and atmosphere. The soft haze between the large mountain and the distant ones is a mix of white and Prussian blue.

White + speck Prussian blue + speck cadmium yellow light

White + speck Prussian blue

Mountain base: White + ultramarine blue + cadmium red light + speck burnt sienna

Lemon yellow + speck Prussian blue

Yellow ochre + cadmium orange + speck white

Burnt umber (base)

White + cadmium yellow medium + speck cadmium red light

White + olive green (made from yellow ochre + ultramarine blue)

Cadmium yellow light + speck ultramarine blue

Yellow ochre + burnt sienna

Painting with Neutrals

The colors at right combine to create the beautiful range of color in the paintings below, including the subtle neutral shades that result from the mixing of the complementary colors. In nature, you'll often see complements paired together. For example, though the greens in different species of trees vary a great deal, they all contain at least a speck of color in the red range. Combining these complements is the natural way to obtain grays. And when colors are grayed correctly, any fresh color placed with them will sparkle.

As mentioned before, black is not a natural graying color; since it is the absence of light, it only deepens the color's value. But black can be used to shade a color, creating a different visual color. For example, yellow shaded with black appears green, and red shaded with black appears purple. When black is used in this manner (as a pigment) it falls into the blue family, because any blue mixed with yellow makes green and any blue mixed with red makes purple. (Note: Burnt umber and ultramarine blue make a beautiful black.)

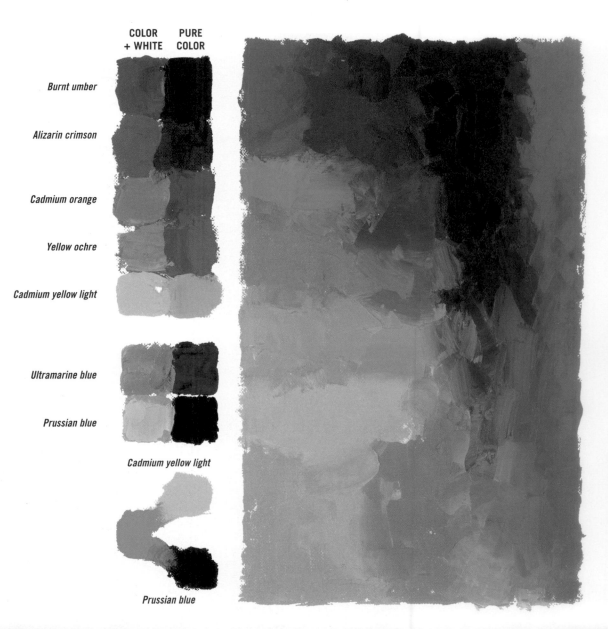

COLOR + WHITE PURE COLOR

Burnt umber

Alizarin crimson

Cadmium orange

Yellow ochre

Cadmium yellow light

Ultramarine blue

Prussian blue

Cadmium yellow light

Prussian blue

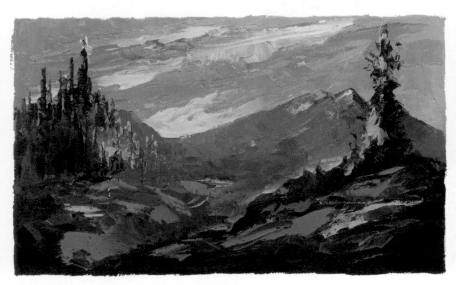

Pale blue and warm orange blend together in the transition area to create rich neutral mixes.

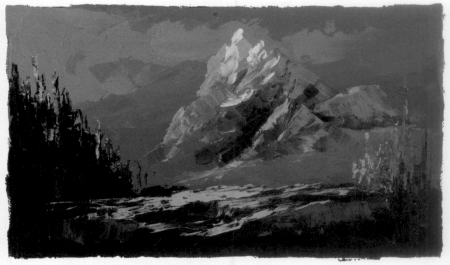

Notice the sparkle of the grass against the background grays.

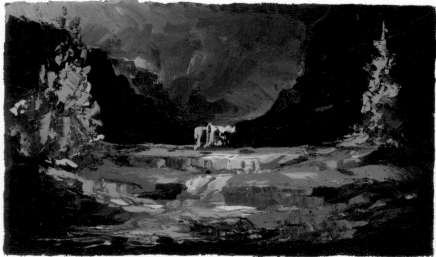

Here grayed yellows and greens are placed against a warm foreground.

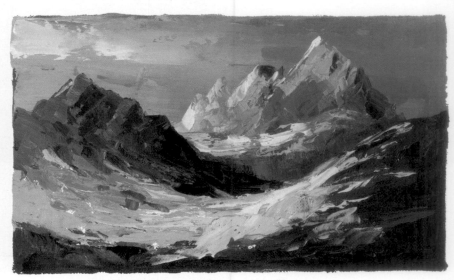

Blue and its complement, orange, make this scene come alive.

Layering Light Colors Over Dark Neutrals

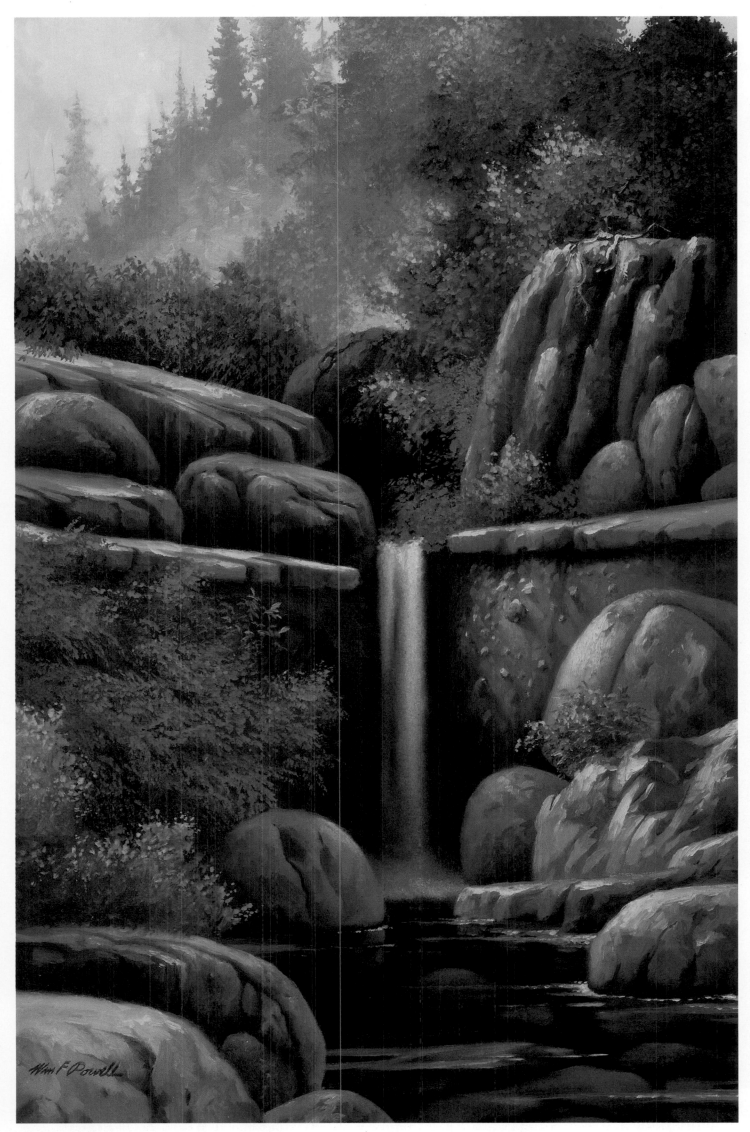

THIS FRAGILE WORLD In this delicate rendering of nature untouched, the creek has rocks that appear both above and below the water. Darken the rocks just a touch near the waterline; they are generally darker when wet.

Interweave foliage among the rock forms, and show the most detail in the foreground. Notice that the light source is from the left and is low enough to create some soft shadows.

PALETTE
Burnt umber, burnt sienna, alizarin crimson, cadmium orange, yellow ochre, cadmium yellow light, lemon yellow, ultramarine blue, cerulean blue, Prussian blue, white

Note: Even though this painting requires ten colors plus white, the palette is not considered extensive. Each color is necessary for the mixtures listed below.

SKY
White + lemon yellow and white + cadmium yellow light; lighten as you move into horizon area

BACK TREES
Sky color + yellow ochre and ultramarine blue

MIDDLE TREES
White + ultramarine blue + alizarin crimson; shade with speck burnt umber

TOP BUSHES
Block in with an olive color of 2 parts yellow ochre + 1 part ultramarine blue

Highlight with cadmium yellow light + cerulean blue and lemon yellow + speck Prussian blue. Add a speck of burnt sienna to bronze the greens.

MIST BETWEEN THE TREES AND BRUSHES
White + speck cerulean blue

HIGHLIGHT GLOW AT BASE OF BUSHES
White + speck lemon yellow

ROCKY LEDGE
Base color is burnt umber + alizarin crimson. Then sienna, orange, and yellows are painted into it for light form.

For the rocks below the ledge and in the stream, add more yellow ochre, cadmium yellow light, and white. Keep the highlights cool on the right, and warm the rocks on the left with ultramarine blue.

Highlight the bushes with the same mixes used for the top bushes. Use less, however, for balance and interest.

WATER
Paint solid areas with a mix of burnt umber + Prussian blue. This makes a black-green.

While the color is wet, paint in the submerged rocks with white + yellow ochre. Blur with a soft, dry brush. Then paint the surface effects with white + ultramarine blue.

Achieving Continuity

PALETTE

Burnt umber, burnt sienna, alizarin crimson, cadmium red light, cadmium orange, cadmium yellow light, ultramarine blue, cerulean blue, titanium white

BASIC MOUNTAINS

White + ultramarine blue + cadmium red light

PURPLE SHADOWS

White + ultramarine blue + alizarin crimson

BASE OF MOUNTAIN

Above mix + more cadmium red light and cadmium orange

DARK TREES

Ultramarine blue + burnt umber + cadmium yellow light

TREE HIGHLIGHTS

Cadmium orange and cadmium yellow light + ultramarine blue and cerulean blue

Note: Add white and burnt umber to soften the brilliance of the greens.

SKY AND SHADOW SNOWS

Ultramarine blue + cerulean blue + white To warm, add more ultramarine blue; to cool, add more cerulean blue.

SUNLIT SNOW

White + cadmium orange

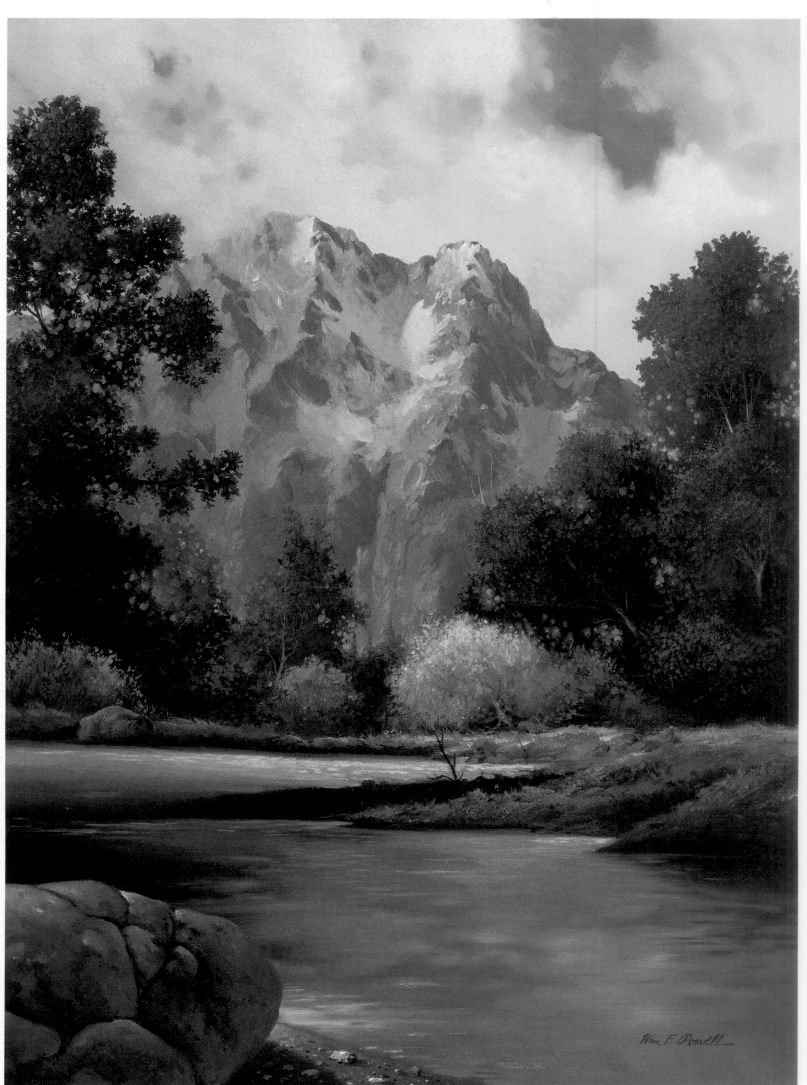

FADING SNOWS Color harmony and continuity are extremely important in painting. One way to achieve these effects is to add a bit of one color (or a selected gray) to all of the color mixtures used in a painting. This creates an overall tonal color quality that visually helps hold the finished painting together. Notice that there is a slight feeling of pink throughout this painting; this was accomplished by adding just a speck of cadmium red light to almost all of the color mixes. Be careful when you add a continuity color to its complementary colors (in this case, the greens) so that you don't unintentionally gray the color mixes.

Using Color as a Focal Point

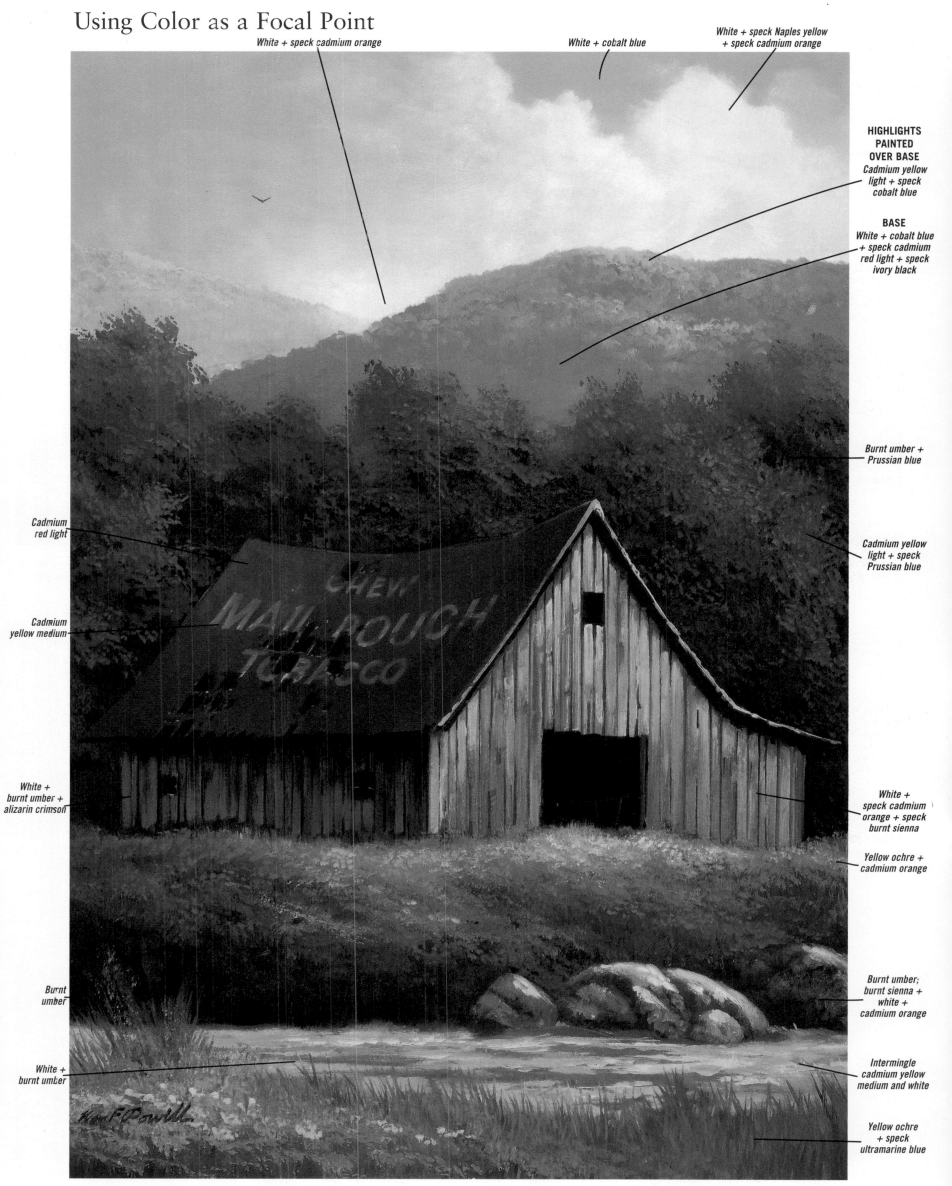

White + speck cadmium orange

White + cobalt blue

White + speck Naples yellow + speck cadmium orange

HIGHLIGHTS PAINTED OVER BASE
Cadmium yellow light + speck cobalt blue

BASE
White + cobalt blue + speck cadmium red light + speck ivory black

Burnt umber + Prussian blue

Cadmium red light

Cadmium yellow light + speck Prussian blue

Cadmium yellow medium

White + burnt umber + alizarin crimson

White + speck cadmium orange + speck burnt sienna

Yellow ochre + cadmium orange

Burnt umber

Burnt umber; burnt sienna + white + cadmium orange

White + burnt umber

Intermingle cadmium yellow medium and white

Yellow ochre + speck ultramarine blue

YESTERDAY'S BILLBOARD A viewer's attention can be directed to certain areas in a painting through the use of color. The red roof of the barn is a major interest point and also an accent to the surrounding, complementary dark greens. The warm combinations of burnt umber, alizarin crimson, and cadmium red light draw the eye to the barn, and the light color values of old wood textures act as a secondary area of interest.

Working with Grays

This painting exercise demonstrates the simple color wheel theory of mixing color complements across the wheel to create realistic-looking, soft grays. Though the grays used in this painting are soft in nature, they are still very colorful. They've been lightened with white to achieve the desired blue, pink, and purple values.

First mix your colors loosely on the palette with a knife (see the mixes at top right). Then vary the proportions of the knife mixes and further blend them with your brush to achieve the variety of "smearings" in the painting, which are responsible for creating the overall mood.

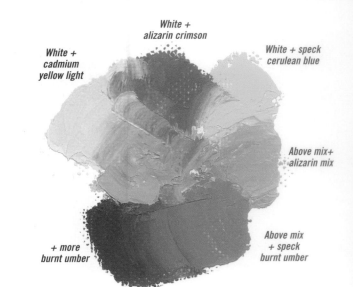

White + cadmium yellow light

White + alizarin crimson

White + speck cerulean blue

Above mix + alizarin mix

Above mix + speck burnt umber

+ more burnt umber

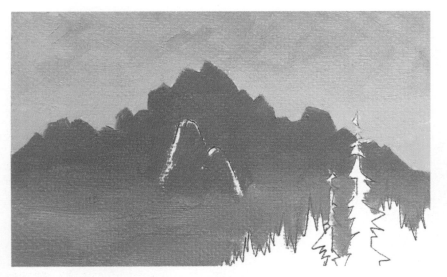

STEP ONE The sky and haze is white and cerulean blue with a speck of pink on the right. Add a speck of burnt umber to this mix for the mountain.

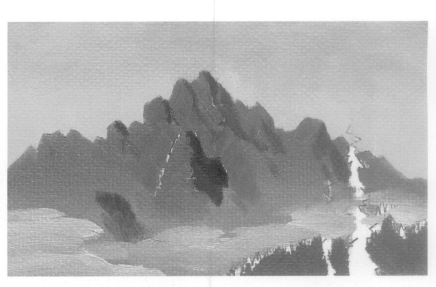

STEP TWO White and alizarin crimson makes the pink glow; add more burnt umber for shadows. Use the mountain color with a speck of cerulean blue for distant trees, and mix white with alizarin crimson for the clouds.

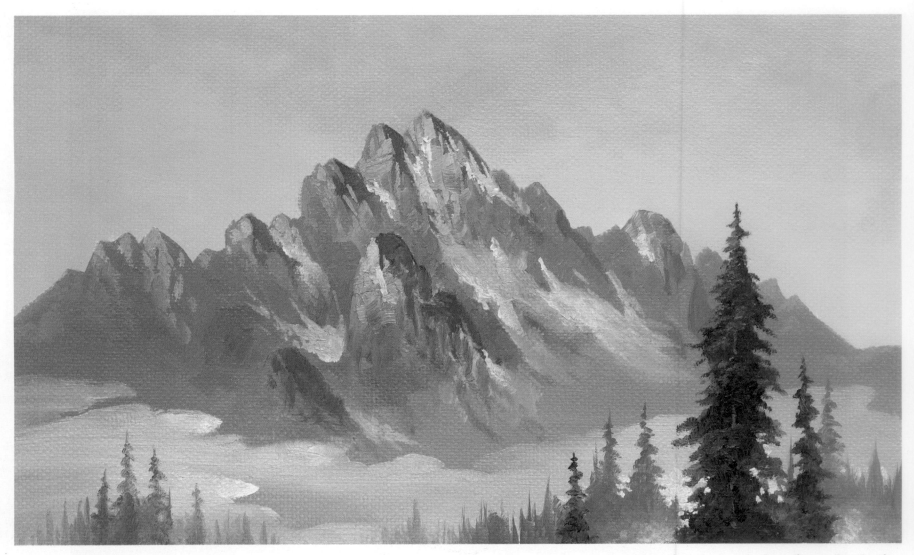

STEP THREE Add the white and yellow mix to the pink for a soft peach glow. Then mix permanent blue and cadmium yellow light with a speck of burnt umber for the dark trees. Use cadmium yellow light with a speck of cerulean blue for the highlight greens. Mix white and permanent blue for the shadow snow and add white to the peach for the sunlit snow. Keep the mixtures smooth and delicate—not harsh and raw. When brushed on, the paint colors intermingle on the canvas to create varied nuances of the original knife mixtures from the palette.

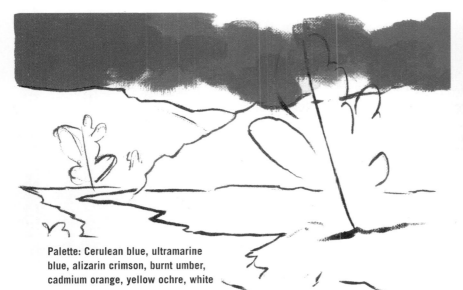 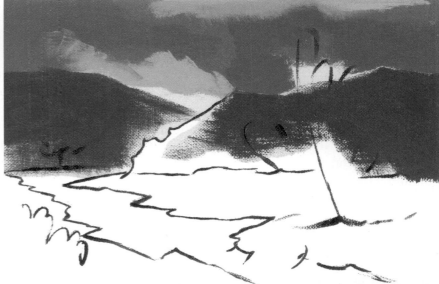

Palette: Cerulean blue, ultramarine blue, alizarin crimson, burnt umber, cadmium orange, yellow ochre, white

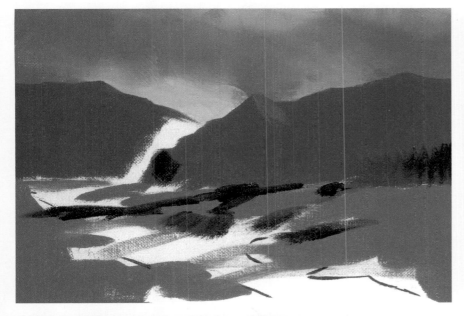 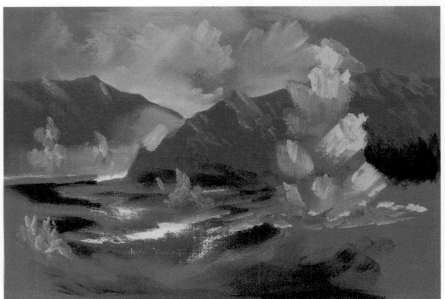

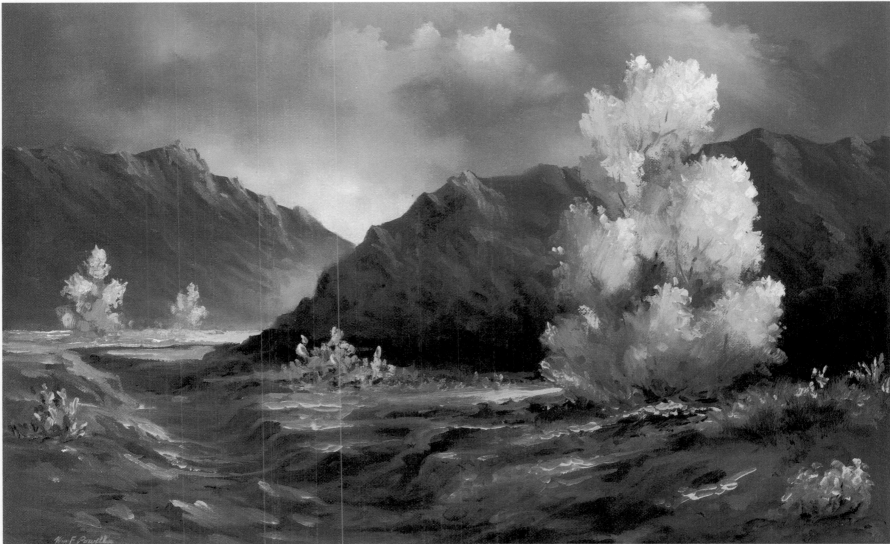

Mix cerulean blue with ultramarine blue to create a "cobalt" blue hue. Then add white for the delicate blue in the shadows. For the dark foreground mountain, mix the shadow blue with specks of alizarin crimson and burnt umber. Watch the values closely to prevent any one area from becoming dominant.

Creating a "Monochromatic Feeling"

A painting with a monochromatic color scheme is made with just one color in various intensities with tints, tones, and shades. You can also use color to create a "monochromatic feeling." A carefully chosen family of colors can create the same overall feeling as a monochromatic painting, yet with a bit more sparkle than a single color would have. This is because one color is selected as the dominant color, and all the other colors are used to accent, gray, or otherwise subtly affect it. The painting below consists of a very simple palette of cerulean blue, permanent blue, alizarin crimson, burnt umber, and titanium white. Choose a color combination of your own, and try creating a painting with a monochromatic feeling.

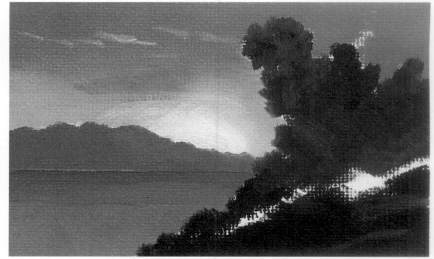

White + cerulean blue

White + permanent blue

White + alizarin crimson

2 parts burnt umber + 1 part alizarin crimson

STEP ONE Use a mix of white and alizarin in different values for the overall dominant color. Add a speck of permanent blue for the subtle purple in the sky and water, and use more white for light.

STEP TWO Continue painting with white, alizarin crimson, and blue. Then add the darks in the foreground with a mix of burnt umber and alizarin crimson. Use the sky colors for lightening and softening.

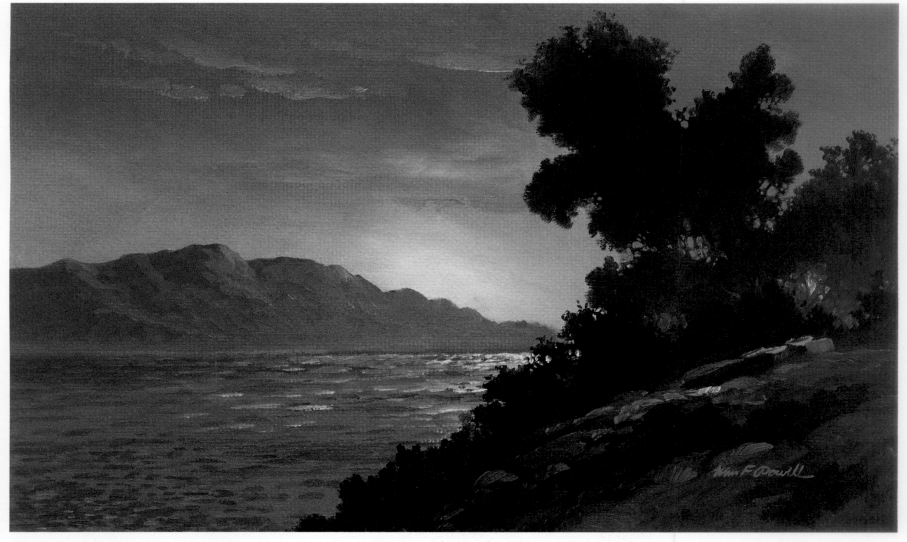

STEP THREE Paint in details with combinations of the colors used previously. Paint the leaves using the corner of a small bright-style sable brush. Add the highlights in the foreground with white, blue, and a slightly stronger mix of alizarin crimson and white. After the painting has dried a bit, go back and paint the spaces where the sky peeks through the trees and bushes.

Establishing Mood with Color

Color affects mood; that is, most people react emotionally to color. For this reason, color is used in the psychology of sales; it is carefully considered when creating print ads and TV commercials. It is also considered carefully in interior design. For example, lively colors such as red and orange (and other warm hues) are not usually used in restful areas such as hospital recovery rooms, but they are used in places such as cafeterias, where people are supposed to move rapidly in and out without feeling hurried. Some examples of different color moods and the typical reactions to each are shown at right.

When direct complements are used in their pure state (without being grayed), they are loud and seem volatile.

Dark purples and blues can be used to create a feeling of mystery and mysticism.

Pale blues and slight hints of greens are considered calm and soothing.

Warm oranges and yellows are energetic and cheerful.

HIGH KEY

A very light painting that contains a lot of white is known as a *high key* painting. Using color in this manner produces a work that is light and airy. In this type of painting, the value changes are very subtle. The three paintings shown here are "thumbnail" oil sketches; they were painted the same size as shown. This is the best way to work out color schemes for larger works.

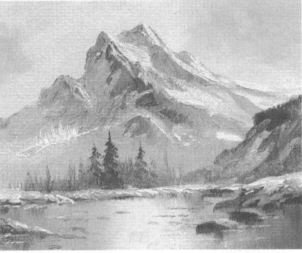

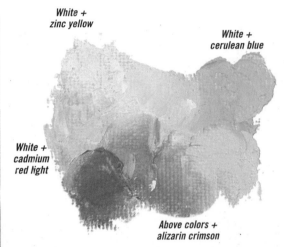

White + zinc yellow

White + cerulean blue

White + cadmium red light

Above colors + alizarin crimson

MIDDLE KEY

Adding a value of gray (produced by mixing white and black) to the colors of a painting creates a *middle key* painting. When using this type of color scheme, you must carefully plan the color mixtures and be sure not to overuse the gray! The idea is to use the gray to just slightly control the colors. Too much gray will mute the colors, making the painting drab.

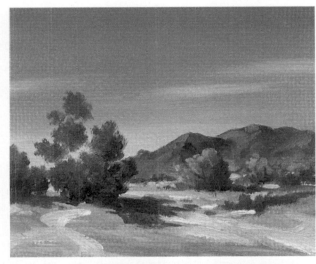

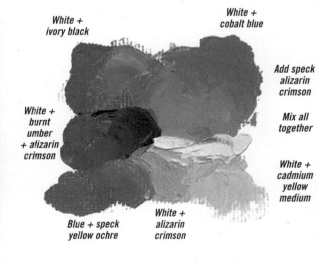

White + ivory black

White + cobalt blue

Add speck alizarin crimson

Mix all together

White + burnt umber + alizarin crimson

White + cadmium yellow medium

Blue + speck yellow ochre

White + alizarin crimson

LOW KEY

Using dark colors and adding black to a theme creates a mood known as *low key* painting. Here the light from the moon plays on the water, and the dark value of the blues and black emphasize the brightness. But black must be used only to control the colors slightly, or the entire painting could become dull. Always try to make your mixtures appear lively in color.

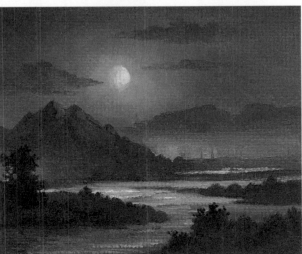

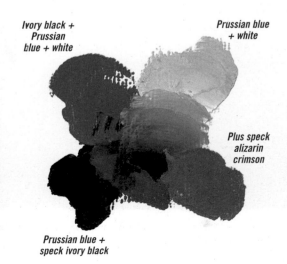

Ivory black + Prussian blue + white

Prussian blue + white

Plus speck alizarin crimson

Prussian blue + speck ivory black

Adding Drama with Color Contrasts

There are many ways to create drama in a painting using color. Sometimes pairing two complementary colors (see pages 1–2) achieves the desired effect, and sometimes a monochromatic or monochromatic-feeling painting is key. Another way to add drama to your piece is by contrasting light colors with dark colors. As you can see in this painting, this combination of colors produces an eye-catching contrast.

Your pigments are capable of producing an infinite variety of mixtures that, when used correctly, will help you create depth, feeling, mood, and texture. But when you want to make a dramatic statement with your painting, it's important for your colors to remain fresh and vibrant.

Notice that the first step here is drawing and blocking in with washes of basic colors. Because the colors need to be strong and true to make an impact, turpentine or thinner are used only to thin the paints for these washes. If you feel it's necessary to thin the pigment during the painting process, try using a painting medium. If thinner is used exclusively, it can weaken the paint and destroy the color; it can also create dull spots on the final piece.

Palette: Burnt umber, burnt sienna, alizarin crimson, cadmium orange, cerulean blue, Prussian blue, ivory black, and white

STEP ONE After drawing, block in washes of the basic colors (use turpentine to dilute oil paints). Once the color is set, wipe away the excess with a soft cloth.

STEP TWO Alizarin crimson and a touch of cerulean blue make a nice orchid color for the soft sky (use a speck of ivory black to deepen the value when necessary). Use white plus a speck of cadmium orange for the clouds and burnt umber plus alizarin crimson and cerulean blue for the ground.

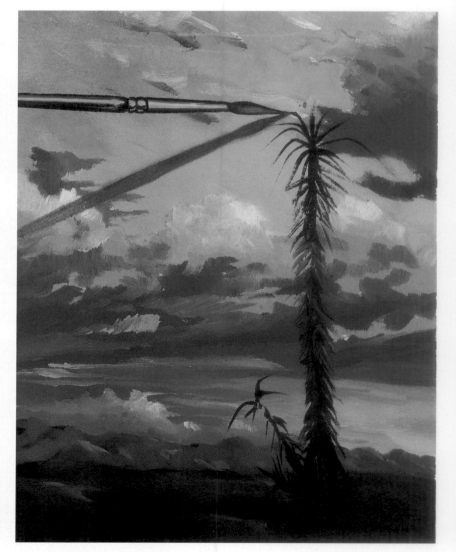

STEP THREE For the base color of the mountains, mix burnt sienna with a speck of cadmium orange; paint the highlights with white plus a speck of orange, and create shadows by blending in some ground mixture. For the grasses, mix orange, white, and a touch of cerulean blue.

STEP FOUR The foliage in the foreground not only acts as an interest point, but it also adds warmth to the painting. Start with the darker colors and then build up the lights. Mix burnt sienna with cerulean blue to create a soft greenish gray. This is a good color to build into either light greens or warm shadows.

Depicting Time of Day

When planning a painting, you must consider time of day because the color of light changes throughout the day. For example, in the morning, the light source is cool, and all objects touched by it will appear more blue. To help portray the time of day, select a category below and add a little of that color into all the mixes in your painting.

Early morning: Lemon yellow
Mid morning: Cadmium yellow light
Midday: Cadmium yellow light/cadmium yellow medium
Early afternoon: Cadmium yellow medium
Late afternoon: Cadmium orange
Early evening: Cadmium red light/alizarin crimson
Evening: Blue-purple

Cerulean blue + ultramarine blue *Ultramarine blue + alizarin crimson*

Lemon yellow *Cadmium yellow light* *Cadmium yellow medium* *Cadmium red light + alizarin crimson*

The three examples on this page show the same subject at different times of day.

Early morning light provides a cool sky and cool highlights on trees and mountains. (The low angle of light also shows that it is morning.)

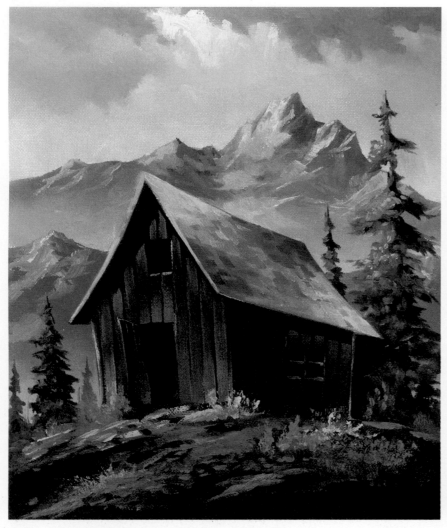

The sky and the mountains appear a bit warmer in the afternoon. The shadows moved from the left to the right as the sun moved across the sky.

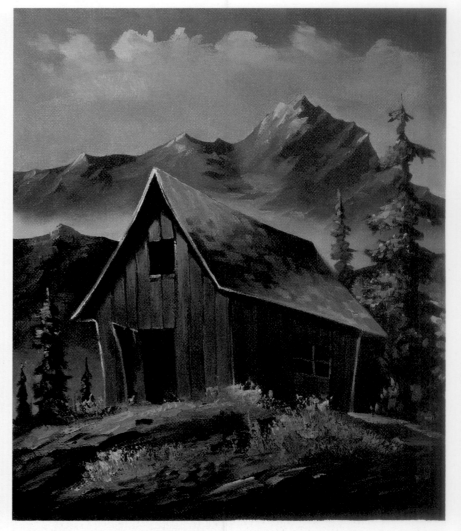

Early evening brings a quiet time; the colors must be quiet also. All areas of the painting should be deeper in tone. Soft mixtures and textures also enhance the mood.

Mastering Color from Dawn to Dusk

MORNING

Morning colors are softer and cooler than afternoon colors because in the morning the air is clearer and the earth is cooler, creating cleaner light. Although the light is soft, there are still a lot of color dramatics in the morning. (The paintings on this page are thumbnail oil sketches; they are shown actual size.)

The great change in values between the shadowed foreground and the soft sky add to the impact of this sunset.

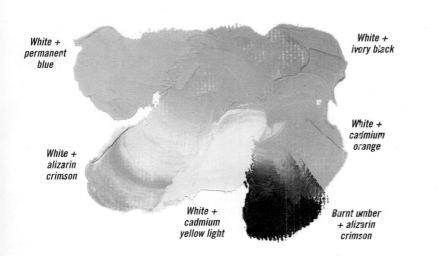

White +
permanent
blue

White +
ivory black

White +
cadmium
orange

White +
alizarin
crimson

White +
cadmium
yellow light

Burnt umber
+ alizarin
crimson

MIDDAY LIGHT AND SHADOWS

Light and shadows are flatter at midday because of the position of the sun (directly overhead). Notice that there are no long shadows.

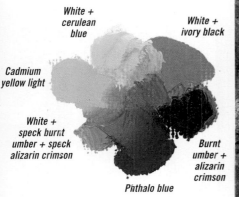

White +
cerulean
blue

White +
ivory black

Cadmium
yellow light

White +
speck burnt
umber + speck
alizarin crimson

Burnt
umber +
alizarin
crimson

Phthalo blue

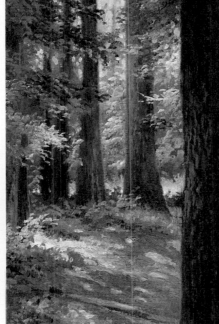

AFTERNOON SOFTNESS

There is sometimes a soft haze that settles in an afternoon scene, as shown in this painting of the Yosemite valley. Use a mixture of titanium white and ivory black to subdue the colors (but use the black sparingly!).

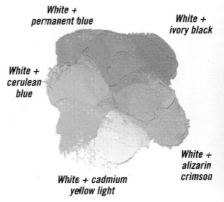

White +
permanent blue

White +
ivory black

White +
cerulean
blue

White +
alizarin
crimson

White + cadmium
yellow light

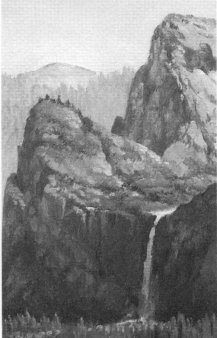

SETTING SUN

A setting sun can be very soft, yet still dramatic. This is especially true over a body of water because the moisture in the air affects the light rays. Here the light source behind the dark clouds projects the rays into the sky, called an "asterism effect." (Note: Sunsets do not have to be bright and heavy with oranges and reds; at times they can be very delicate.)

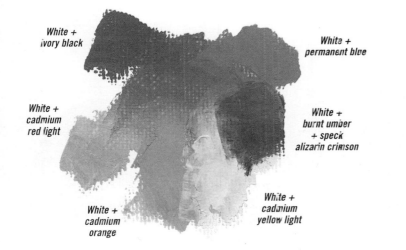

White +
ivory black

White +
permanent blue

White +
cadmium
red light

White +
burnt umber
+ speck
alizarin crimson

White +
cadmium
orange

White +
cadmium
yellow light

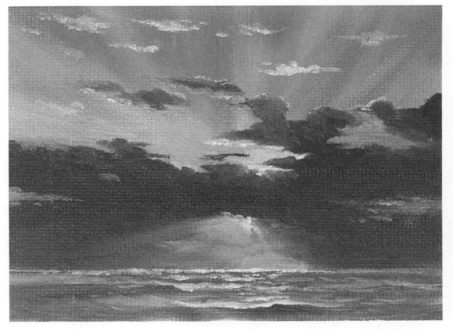

Study sunsets on different days, and notice the color difference between dry days and humid days. Try using a black of your own. A good one to start with is a 1-to-1 mix of burnt umber and permanent blue. You can make the mixture warmer by adding more umber or cooler by adding more blue.

Recording Color Notes

It's always helpful to take notes when you mix colors, whether to remember your pigment and brush combinations or to record ideas and color impressions of a subject while on location.

First study your subject and select the colors that seem to fit. Then mix the values for the main colors of the painting. (These are called "intentionals" because they are deliberately mixed as a spe-

cific value that will work well when combined with all the other mixes). When the desired color mood is achieved, label the colors (1, 2, 3, etc.).

As you paint, you can manipulate and intermix the intentionals on both the palette and the canvas to produce an unending array of colors called "accidentals." These colors are planned accidents, and they make up the majority of color mixes.

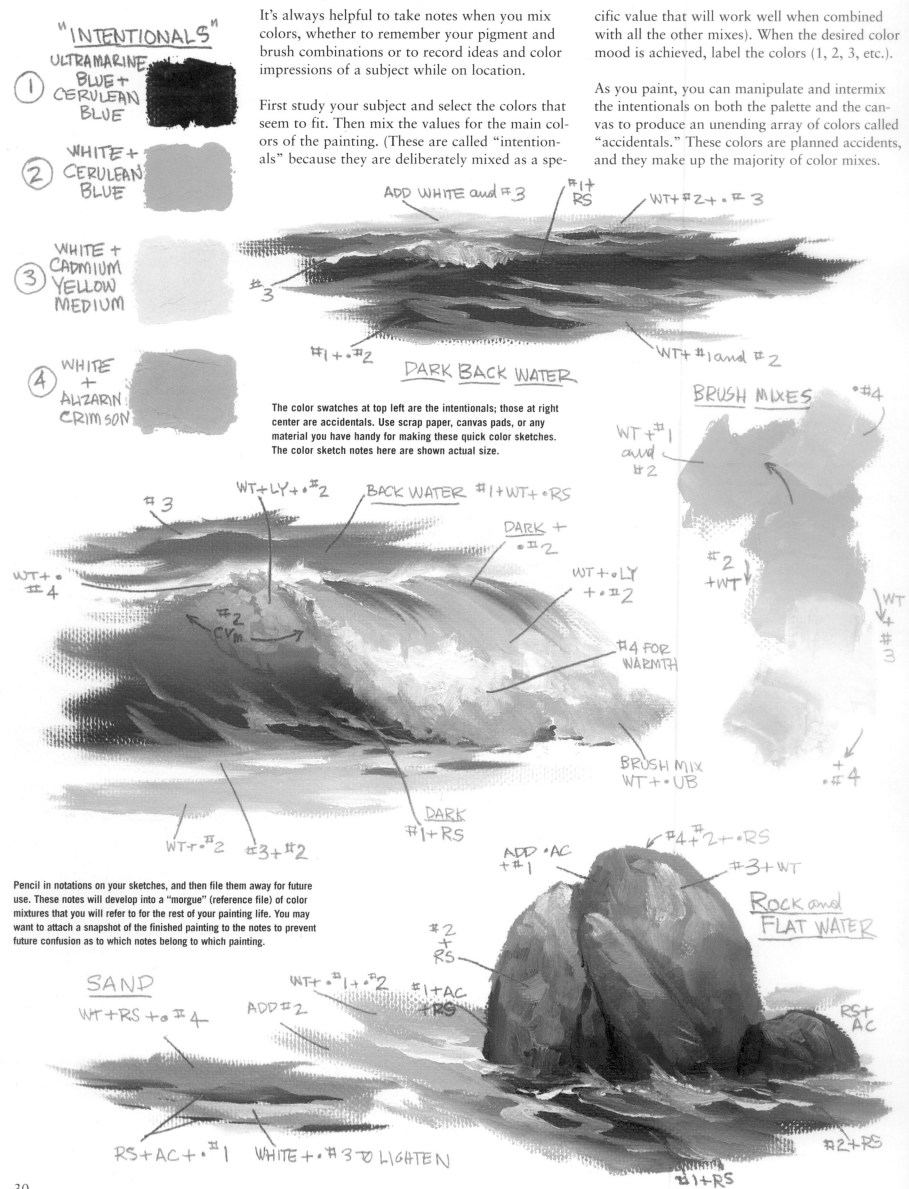

"INTENTIONALS"

1. ULTRAMARINE BLUE + CERULEAN BLUE
2. WHITE + CERULEAN BLUE
3. WHITE + CADMIUM YELLOW MEDIUM
4. WHITE + ALIZARIN CRIMSON

The color swatches at top left are the intentionals; those at right center are accidentals. Use scrap paper, canvas pads, or any material you have handy for making these quick color sketches. The color sketch notes here are shown actual size.

ADD WHITE and #3 #1+ RS WT+#2+•#3

#3

#1+•#2

DARK BACK WATER

WT+ #1 and #2

BRUSH MIXES •#4

WT+#1 and #2

#2 +WT

WT +#3

#3

WT+•#2 BACK WATER #1+WT+•RS

WT+LY+•#2

WT+•#4

#2 CYm

DARK + •#2

WT+•LY +•#2

#4 FOR WARMTH

BRUSH MIX WT+•UB

+•#4

Pencil in notations on your sketches, and then file them away for future use. These notes will develop into a "morgue" (reference file) of color mixtures that you will refer to for the rest of your painting life. You may want to attach a snapshot of the finished painting to the notes to prevent future confusion as to which notes belong to which painting.

DARK #1+RS

WT+•#2 #3+#2

SAND

WT+RS+•#4

ADD #2 WT+•#1+•#2 #1+AC +RS

#2 +RS

ADD•AC +#1 #4+#2+•RS

#3+WT

ROCK and FLAT WATER

RS+ AC

RS+AC+•#1 WHITE+•#3 TO LIGHTEN

#1+RS

#2+RS

Selecting the Proper Colors

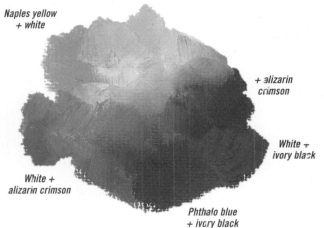

Naples yellow + white

+ alizarin crimson

White + ivory black

White + alizarin crimson

Phthalo blue + ivory black

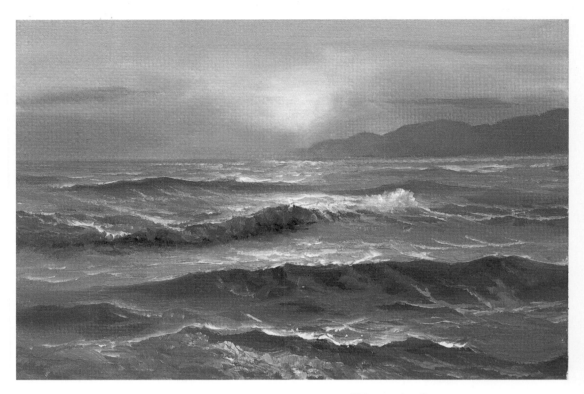

YELLOWS

The dominant color in this painting is yellow, so yellow is known as the "key" color, and a bit of yellow is used in all mixtures. When planning a color scheme and a mood, choose a key color to hold the painting together. This creates an overall unity in the painting, and no color will stand out drastically from the others.

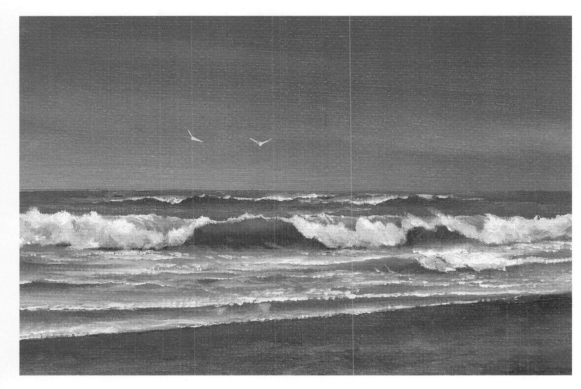

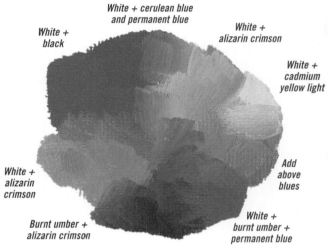

White + cerulean blue and permanent blue

White + black

White + alizarin crimson

White + cadmium yellow light

White + alizarin crimson

Add above blues

Burnt umber + alizarin crimson

White + burnt umber + permanent blue

BLUES AND GREENS

Blue dominates this daylight scene at the beach. Blue is the key color here, as it is added to all mixtures—even the whites and grays of the foam. Notice the use of black in the mixtures. This bluish black was mixed from other colors (as discussed on page 29) to keep it within the color plan. Refer to the paint smearings above, and notice how the greens are mixed.

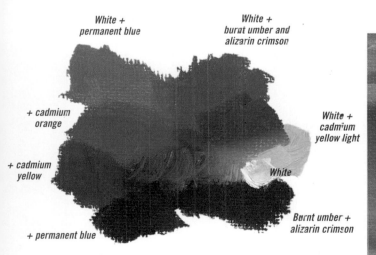

White + permanent blue

White + burnt umber and alizarin crimson

+ cadmium orange

+ cadmium yellow

White

White + cadmium yellow light

+ permanent blue

Burnt umber + alizarin crimson

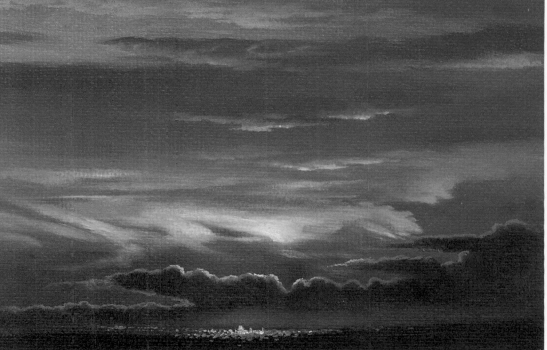

REDS AND ORANGES

The dominant color in this sunset scene is alizarin crimson. Permanent blue and white are added to make purples. Then a combination of burnt umber, alizarin crimson, and permanent blue are used for the dark clouds. The dark land is blue and umber. (These paintings are oil sketches, shown actual size.)

Walter Foster Art Instruction Program

THREE EASY STEPS TO LEARNING ART

Beginner's Guides are specially written to encourage and motivate aspiring artists. This series introduces the various painting and drawing media—acrylic, oil, pastel, pencil, and watercolor—making it the perfect starting point for beginners. Book One introduces the medium, showing some of its diverse possibilities through beautiful rendered examples and simple explanations, and Book Two instructs with a set of engaging art lessons that follow an easy step-by-step approach.

How to Draw and Paint titles contain progressive visual demonstrations, expert advice, and simple written explanations that assist novice artists through the next stages of learning. In this series, professional artists tap into their experience to walk the reader through the artistic process step by step, from preparation work and preliminary sketches to special techniques and final details. Organized by medium, these books provide insight into an array of subjects.

Artist's Library titles offer both beginning and advanced artists the opportunity to expand their creativity, conquer technical obstacles, and explore new media. Written and illustrated by professional artists, the books in this series are ideal for anyone aspiring to reach a new level of expertise. They'll serve as useful tools that artists of all skill levels can refer to again and again.

Walter Foster products are available at art and craft stores everywhere.

For a full list of Walter Foster's titles, visit our website at www.walterfoster.com or send $5 for a catalog and a $5-off coupon.

WALTER FOSTER PUBLISHING, INC.
23062 La Cadena Drive
Laguna Hills, California 92653
Main Line 949/380-7510
Toll Free 800/426-0099

www.walterfoster.com